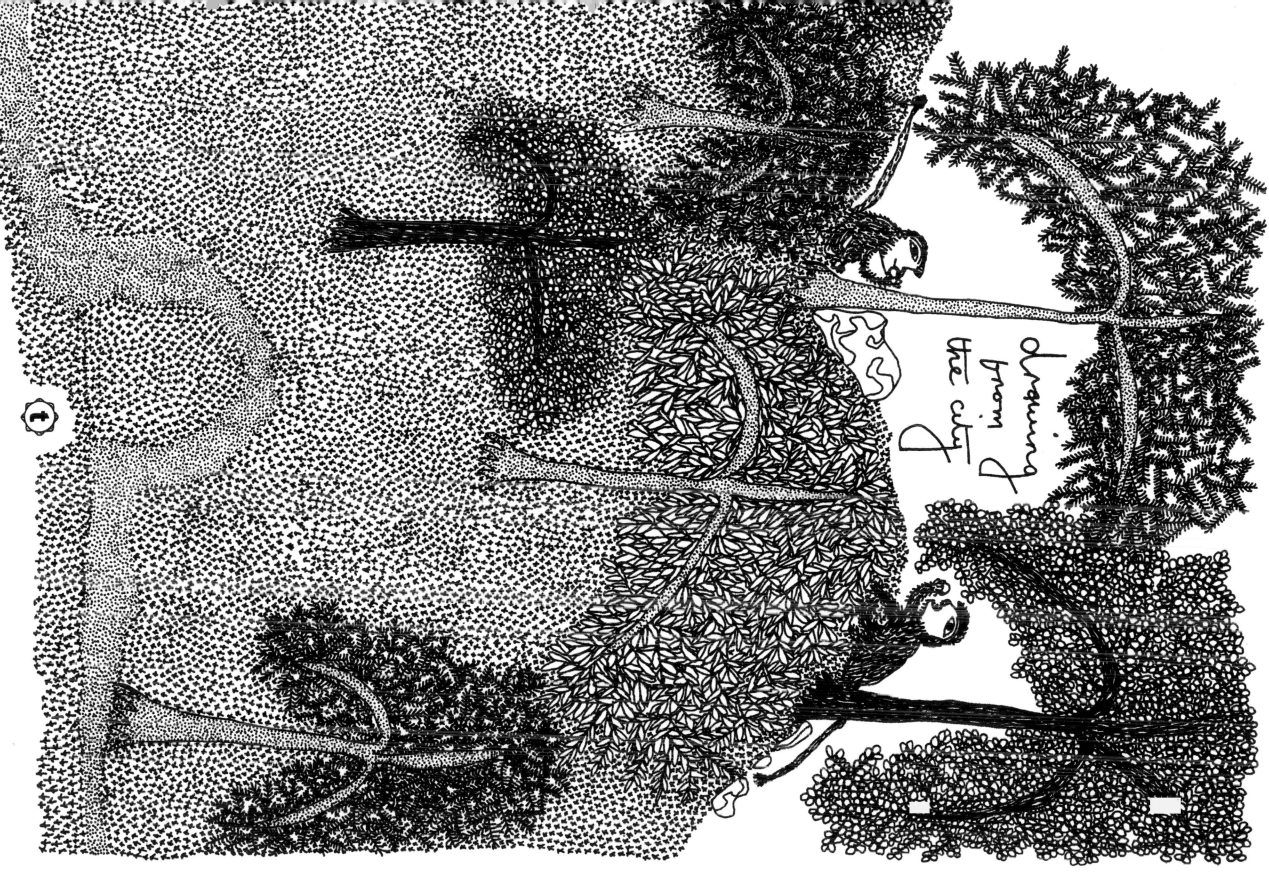

drawing from the city

Based on the oral stories of Tejubehan

Original Tamil text: Saalai Selvam English text: V. Geetha & Gita Wolf

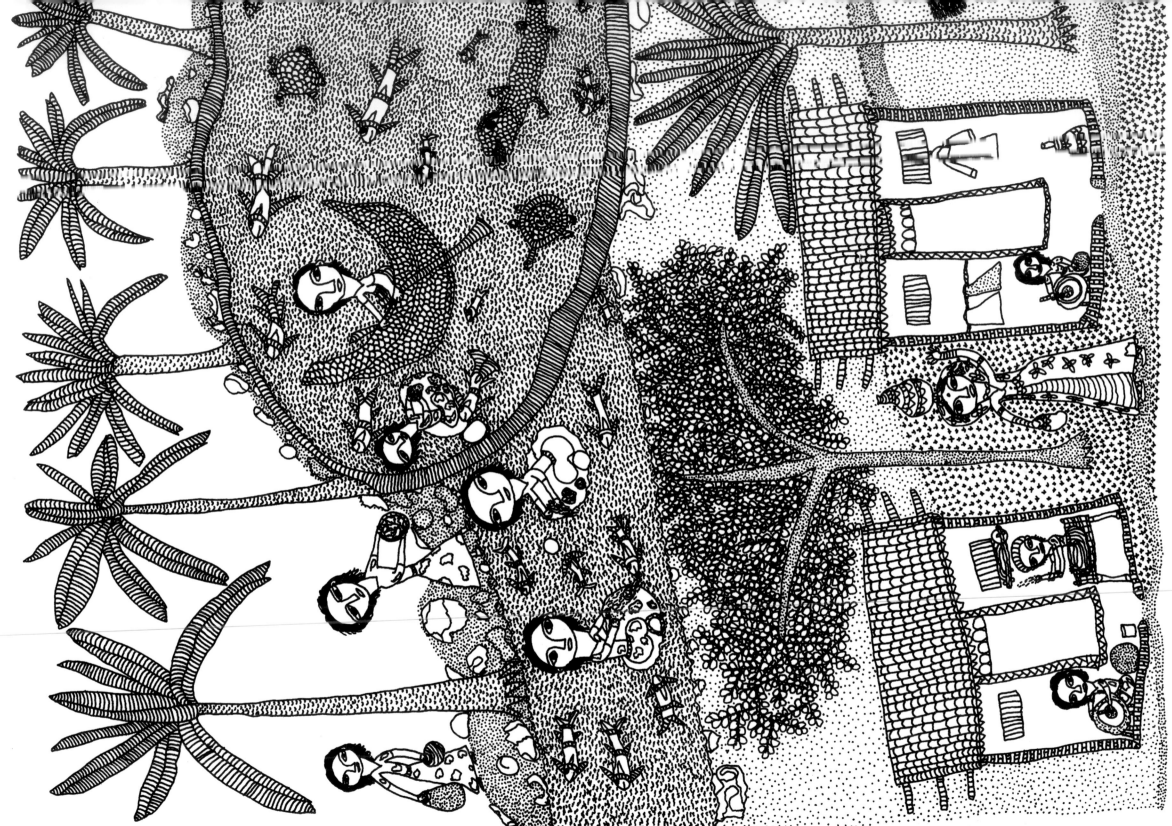

They call me Teju. Here I am, as a little girl in our village. I feel at home indoors as well as outdoors, and my favourite place is near the stream that runs behind our hut.

Our village is green at times. But, often when the summer is hot, it is baked brown. The fields are empty and the stream dries into a cracked bed. Our house is tiny. All of us have to work for all of us to eat. It's not just us. Everyone around us lives like we do.

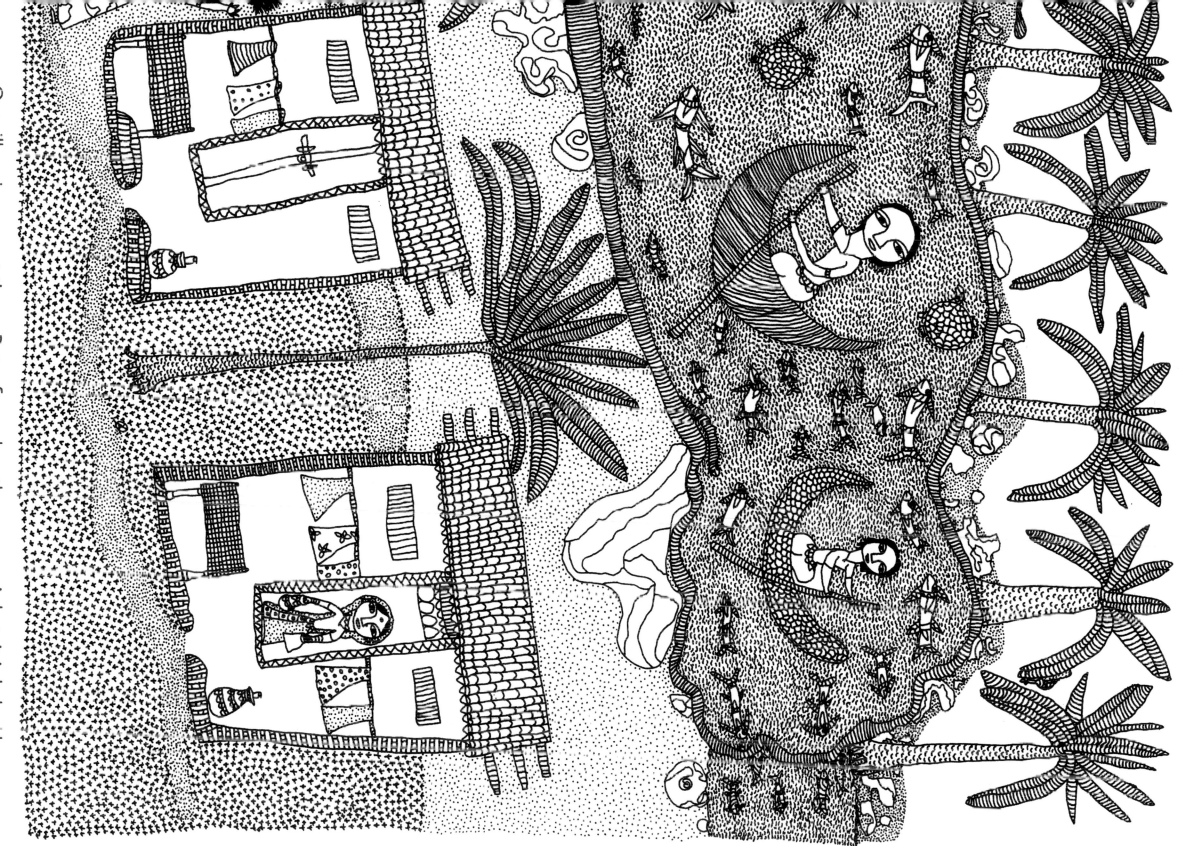

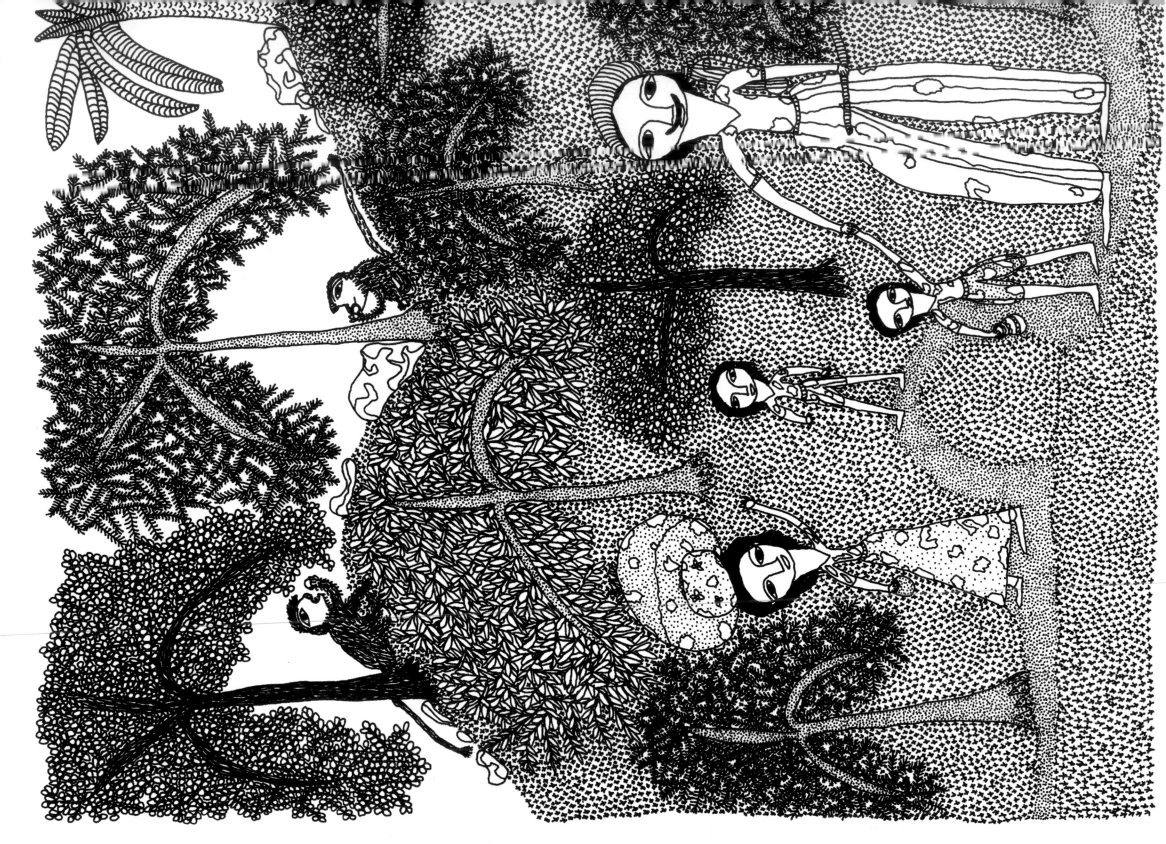

Work takes us to the forest nearby. I never go alone. Pa and Ma, our neighbours and their babies — we all go together. It is scary to be by yourself amongst the trees. You hear things that rustle, whisper, breathe... I hold my father's hand tight.

He taps his stick on the ground, or on a tree-trunk. He tells me that it is his way of telling the forest it has visitors.

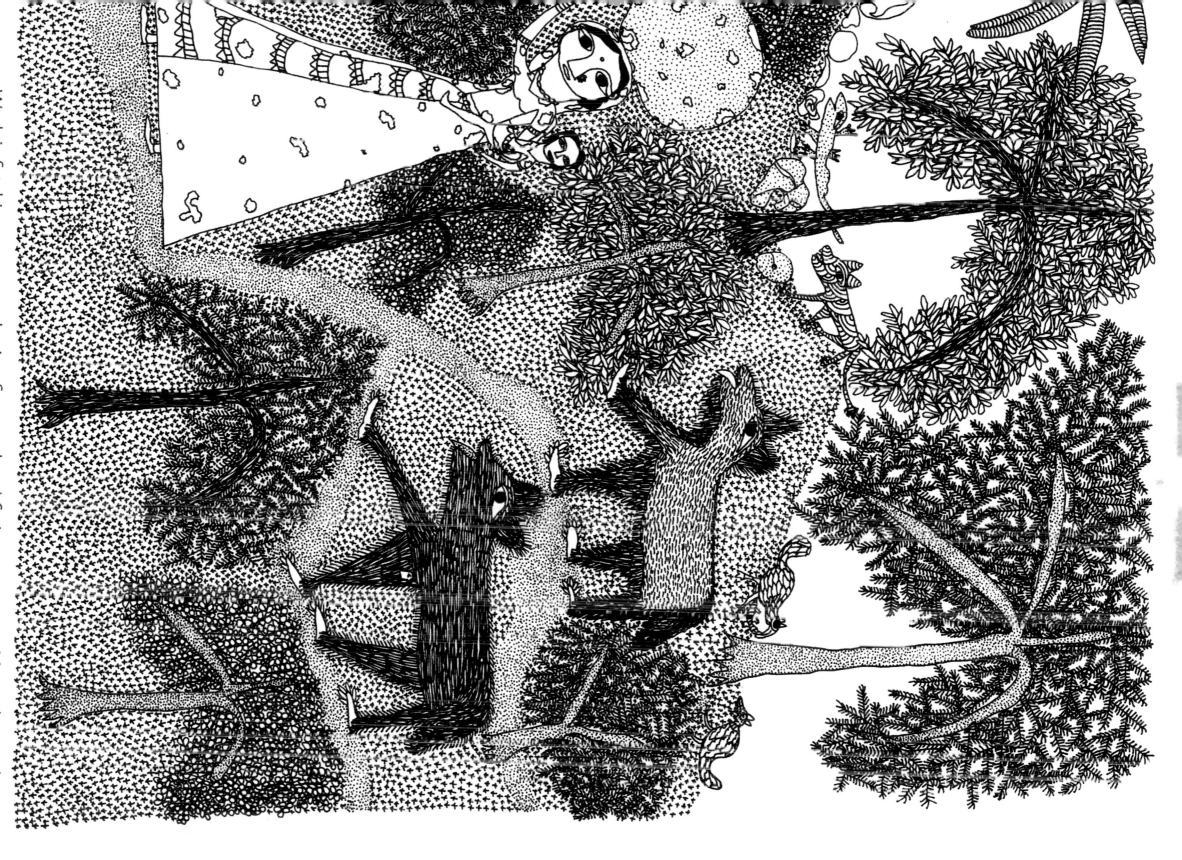

Work is fetching water, gathering firewood and fruit we can eat. Ma gathers other things too — seeds, berries, leaves. Ma says you have to listen carefully in the forest. Chirruping squirrels warn you of snakes. The wind brings the smell of rain or a dead animal.

We come home to more work: cooking, washing, cleaning. Sometimes, Pa and Ma go off again, to work on rich people's fields.

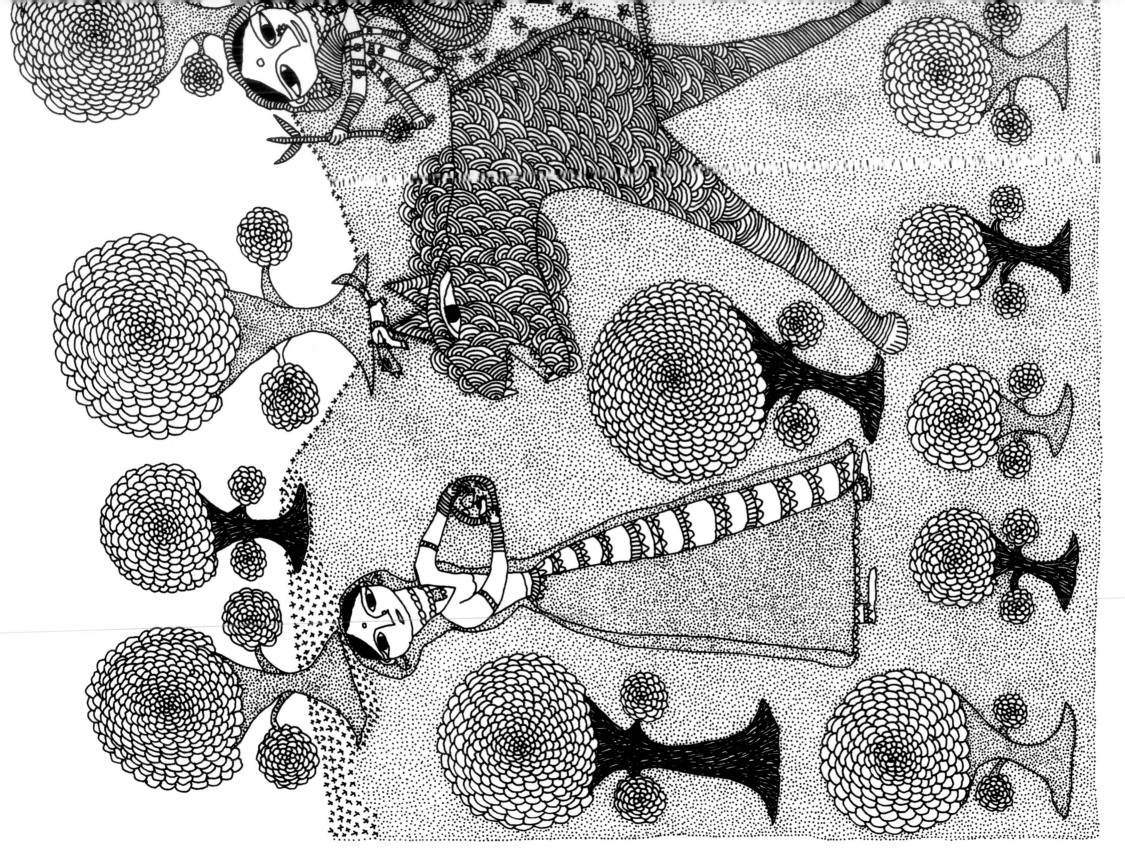

Pa also sings for a living. He leaves early in the morning, going from house to house, singing songs about god, love, pain and happiness. In return, people give him money or grain.

Ma does not go with him. She loves to sing, but in our village, women don't sing in public. Ma chants though. Her chanting is musical and soothing, as she prays to the village goddess.

Our goddess is armed and rides a tiger, and Ma says she is both kind and fierce. All the women in the village pray to her. They ask for different things: for rain, for their sick children to get well, for a good harvest. I pray sometimes, with Ma. Ma tells me that it is the goddess who takes care of the poor, but I don't know about that. Because we continue to stay poor.

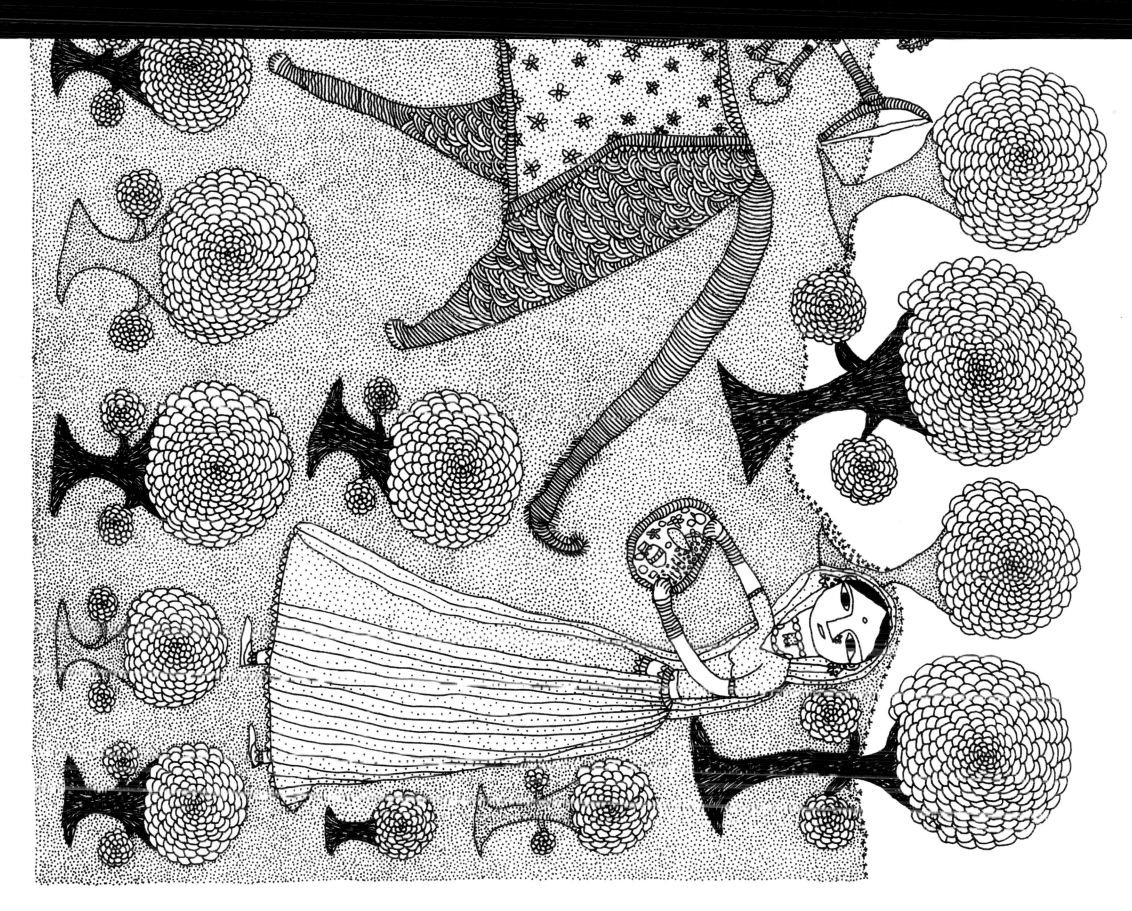

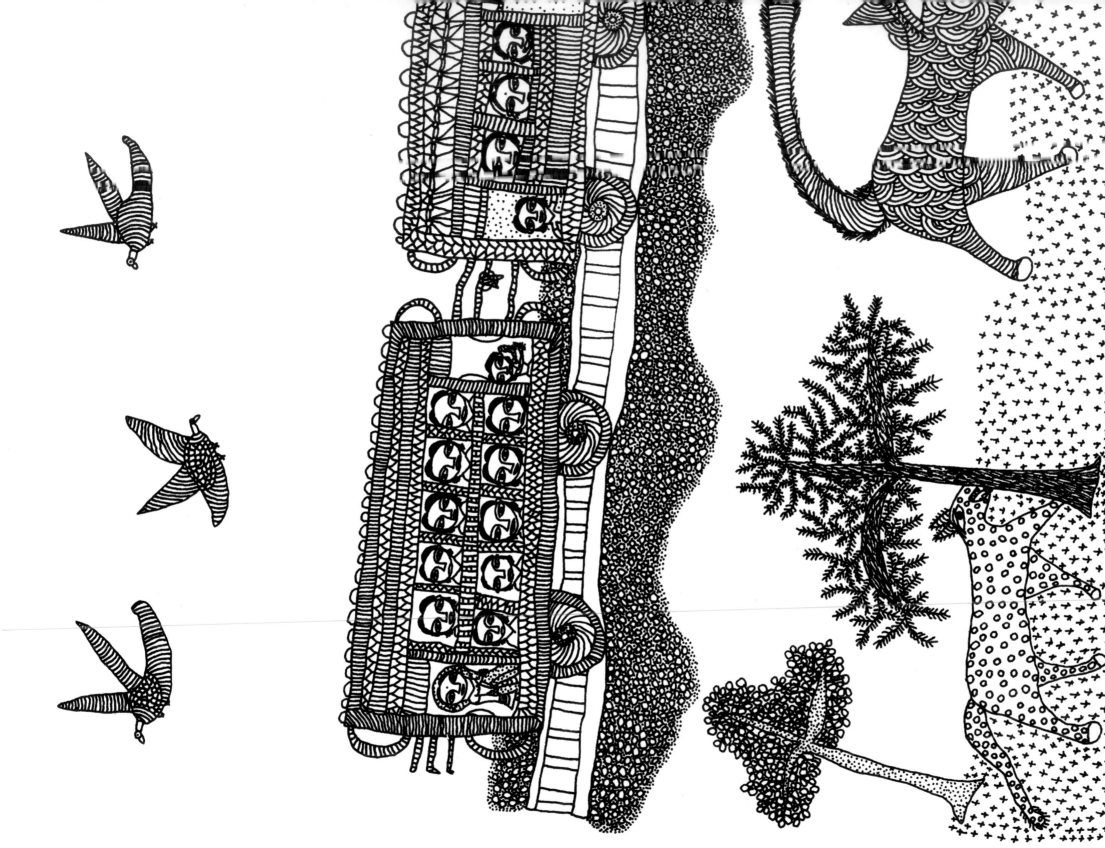

They say the poor have nowhere to go. I'm not sure. When people don't have enough to eat, they take the train to the city, to find work. A railway line runs along the edge of the forest. If you walk along the tracks for about five miles you come to the station.

A train runs faster than any animal or bird I know. I like to stand at the edge of the forest and watch the trains as they rush past. I see people looking out of the windows.

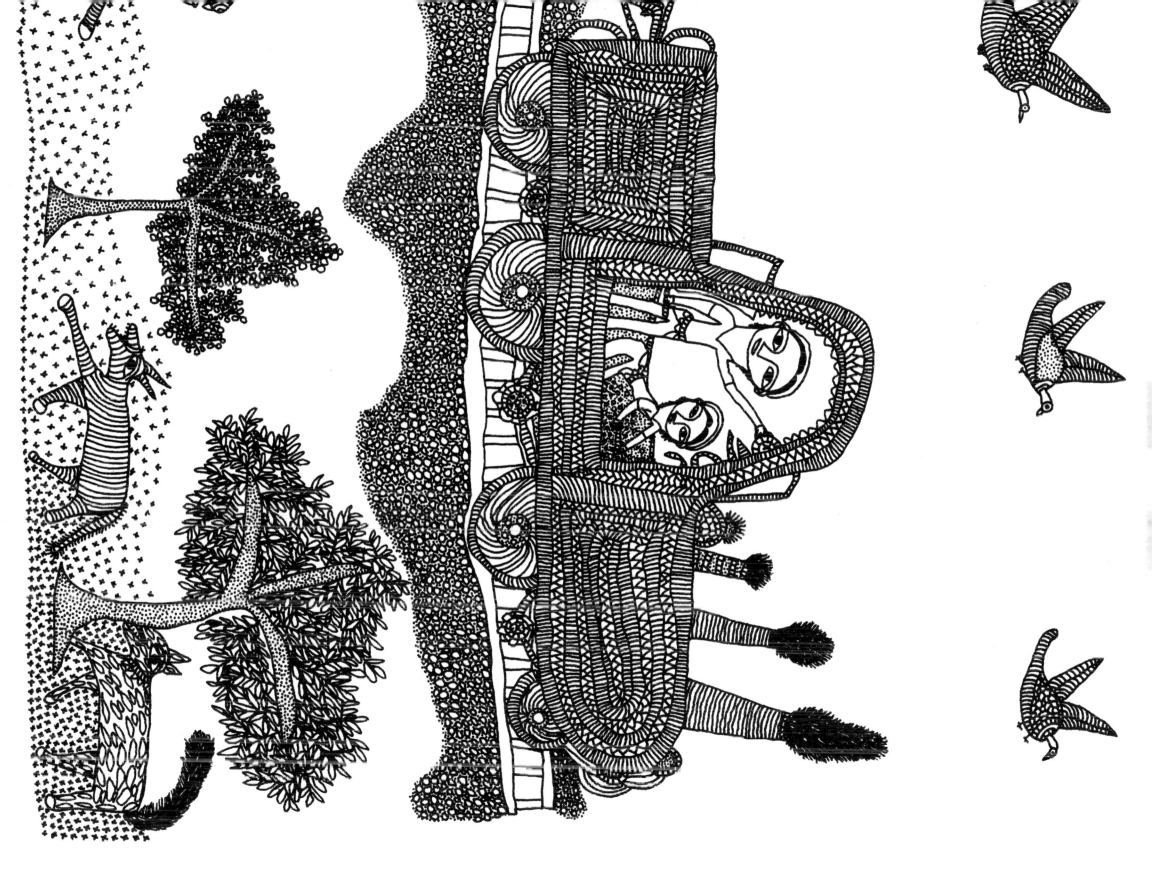

They are not like the people in the village, they are like faces you see on calendars, or in photos. Lucky people, I think, they don't have to work. They can sit and stare at the world going by.

I like to think of myself getting on to one of those trains. I want to be on the move. Whenever I feel that way, I walk along to the station. I wait for a train to stop, then I walk up and whisper: take me to the city.

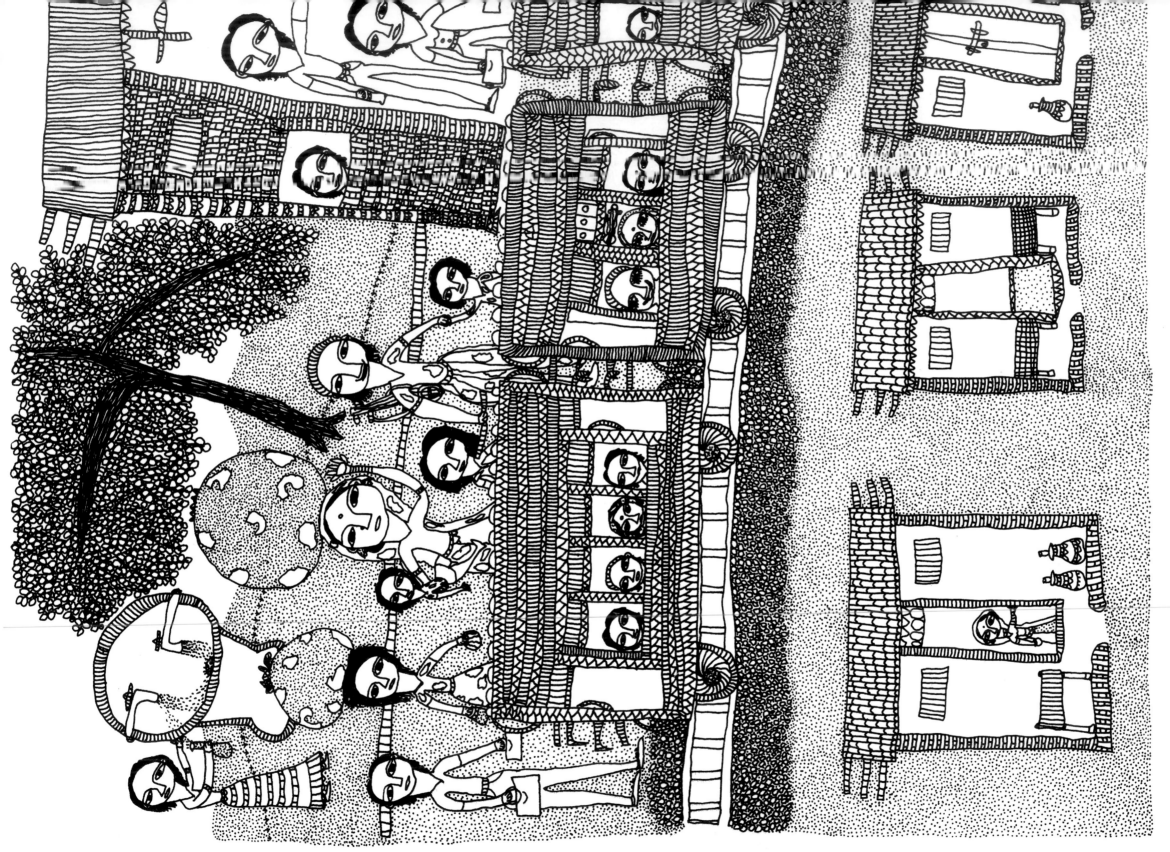

And then it does happen. We find ourselves at the station one busy night, waiting for a train. The station is a crowded place, and tonight there is no place to move. We are a large group of people, on our way to the city. It's strange: I'm excited about getting on the train, but it is not like I imagined. A red hot summer has passed, and after two months, there is still no sign of rain. Clouds of dust settle on our hair and clothes.

We are hungry and thirsty. Ma has grown thin, since she gives us what there is, and does not eat herself. I am a big girl now, nearly 13, so I understand how bad things are. We have to travel to find work, to be able to eat.

So I am ready to go, but not like this. Not with a wan group of people with big bundles and worried eyes.

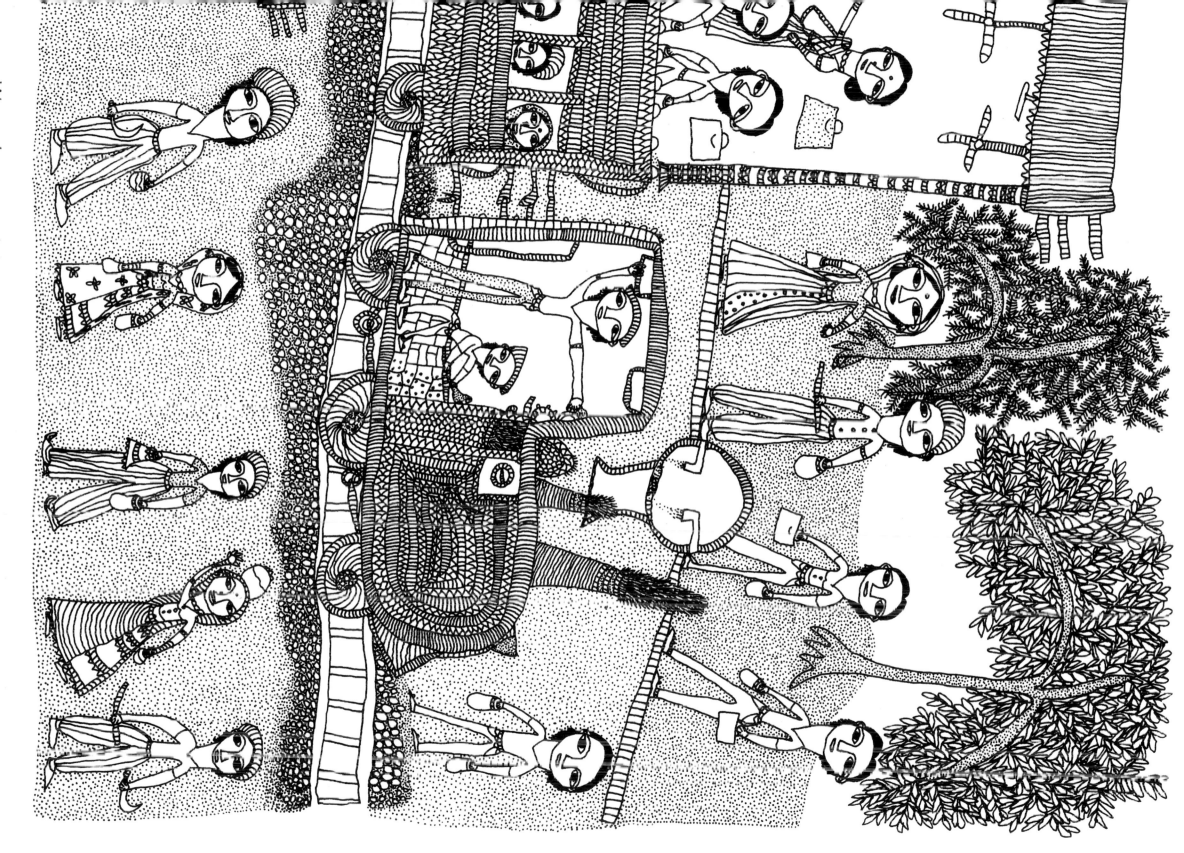

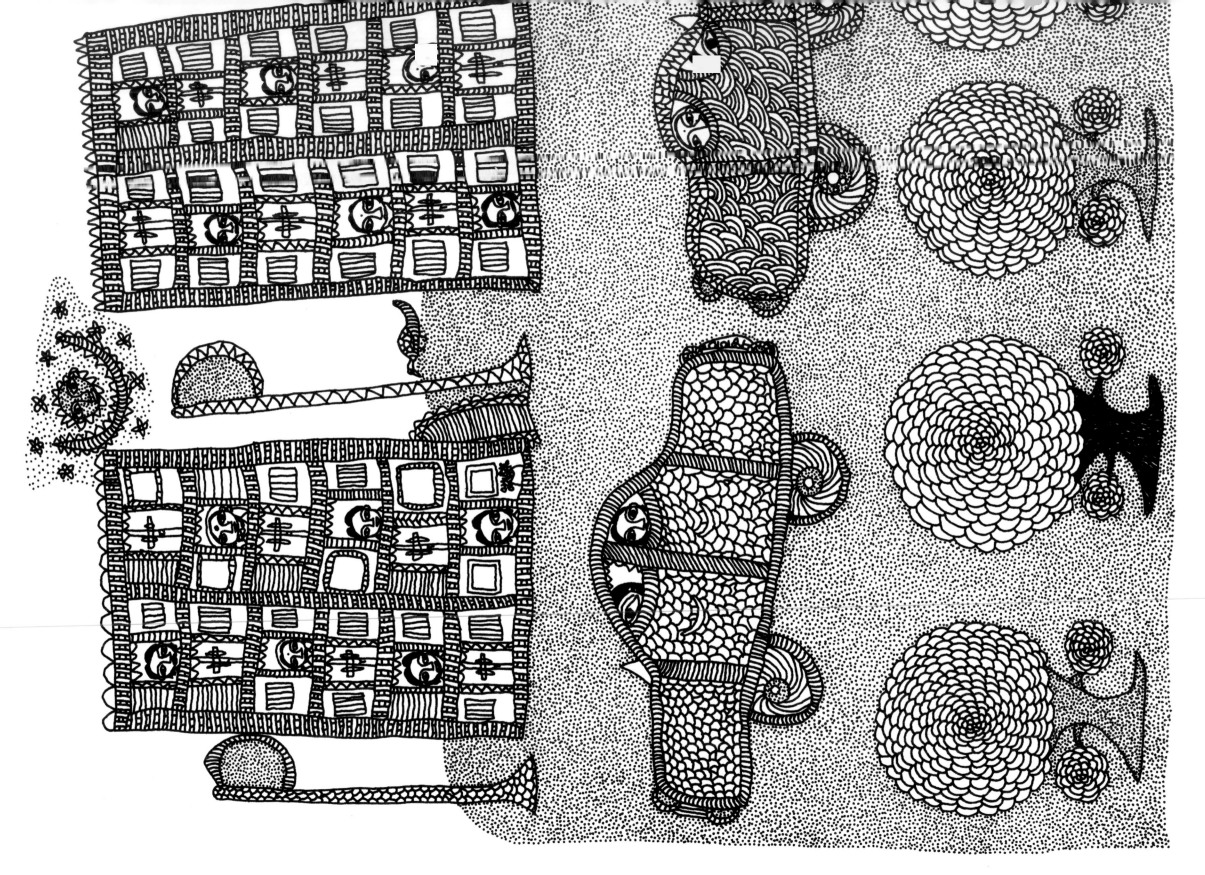

We reach the city! Everything is on the move here, not just the train. People rush past, pushing their way through the streets. Only the tall buildings seem rooted to the spot, along with a few trees that stand guard on the other side.

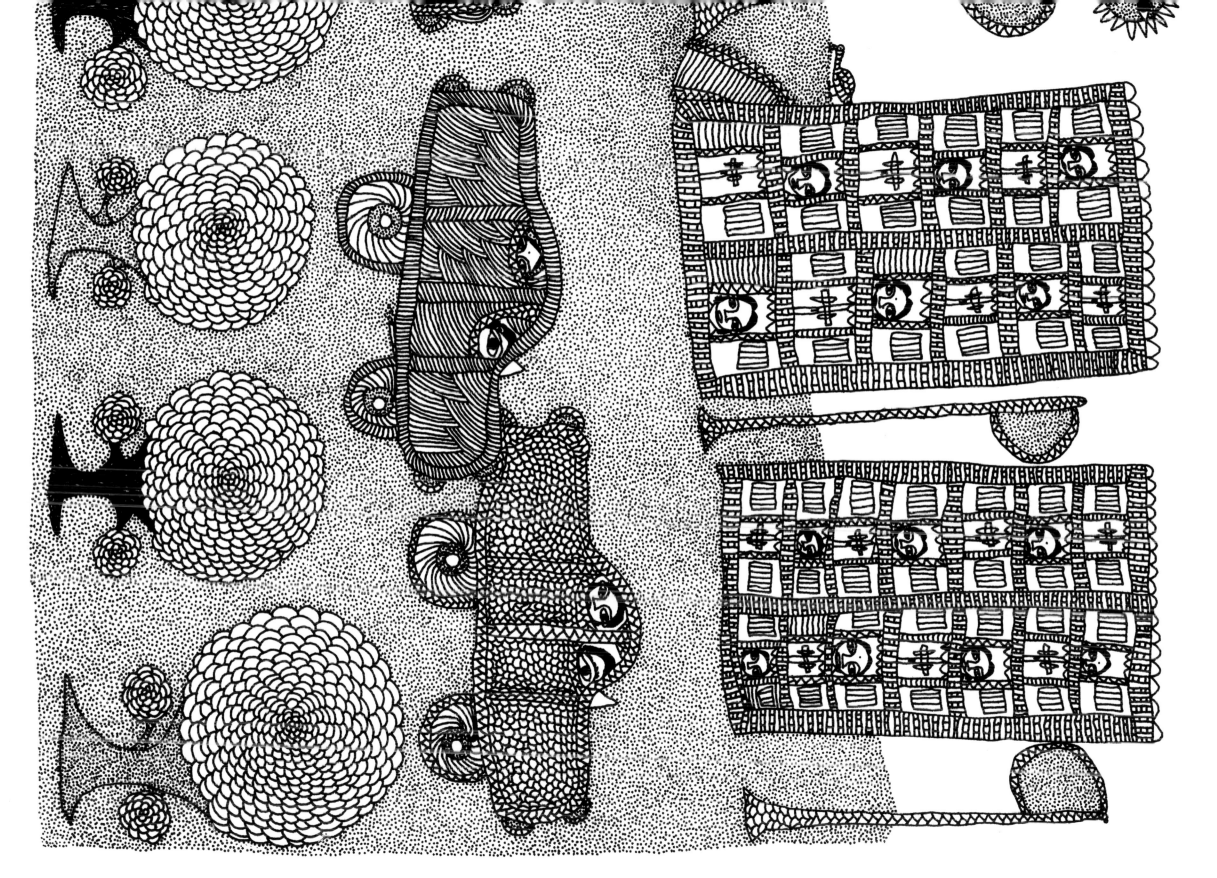

I don't mind the rush though. The sun is setting, and I marvel at the lamposts, that can turn night into day. Nights in our village are really dark.

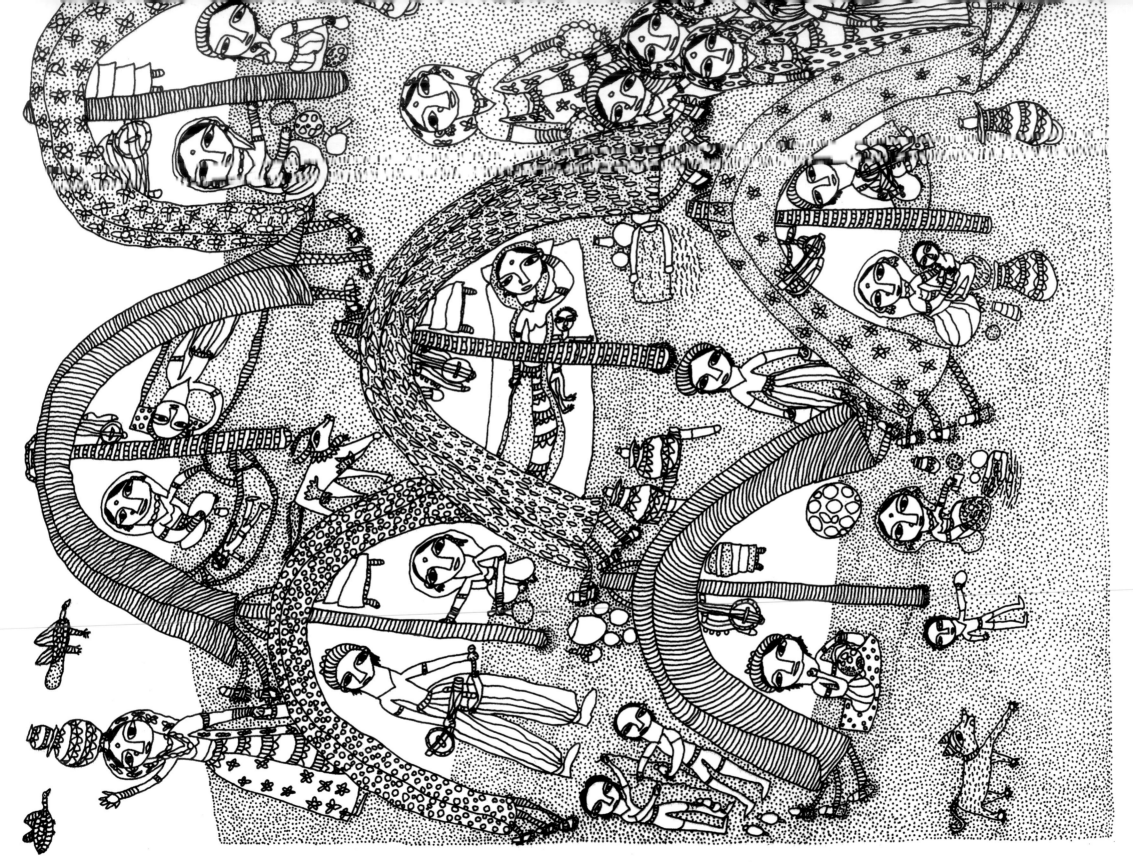

But those tall buildings are not for us. We move on, right to the edge of the city, and begin to build homes for ourselves. They are not made of mud or brick, but of cloth, plastic and gunny bags, anything we can find. We are to live in tents now. At least we're not alone, and so we begin to make a life for ourselves as a small community.

And it is here, in our ragged tent city, that I grow up.

Three years pass.

I am now a young woman, and Ma and Pa decide that it is time to get me married. I am lucky, they find a groom with kind eyes. His name is Ganeshbhai, and he sings for a living, just like Pa did back in the village.

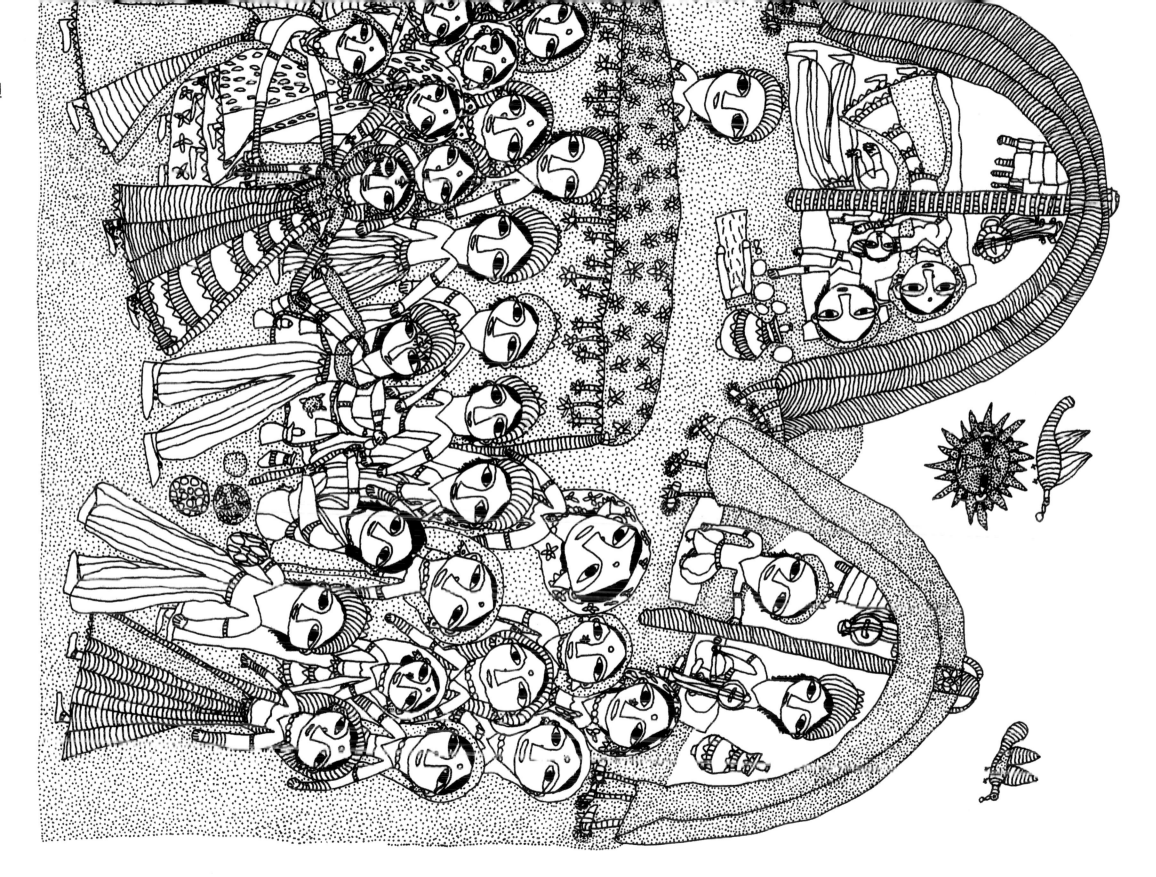

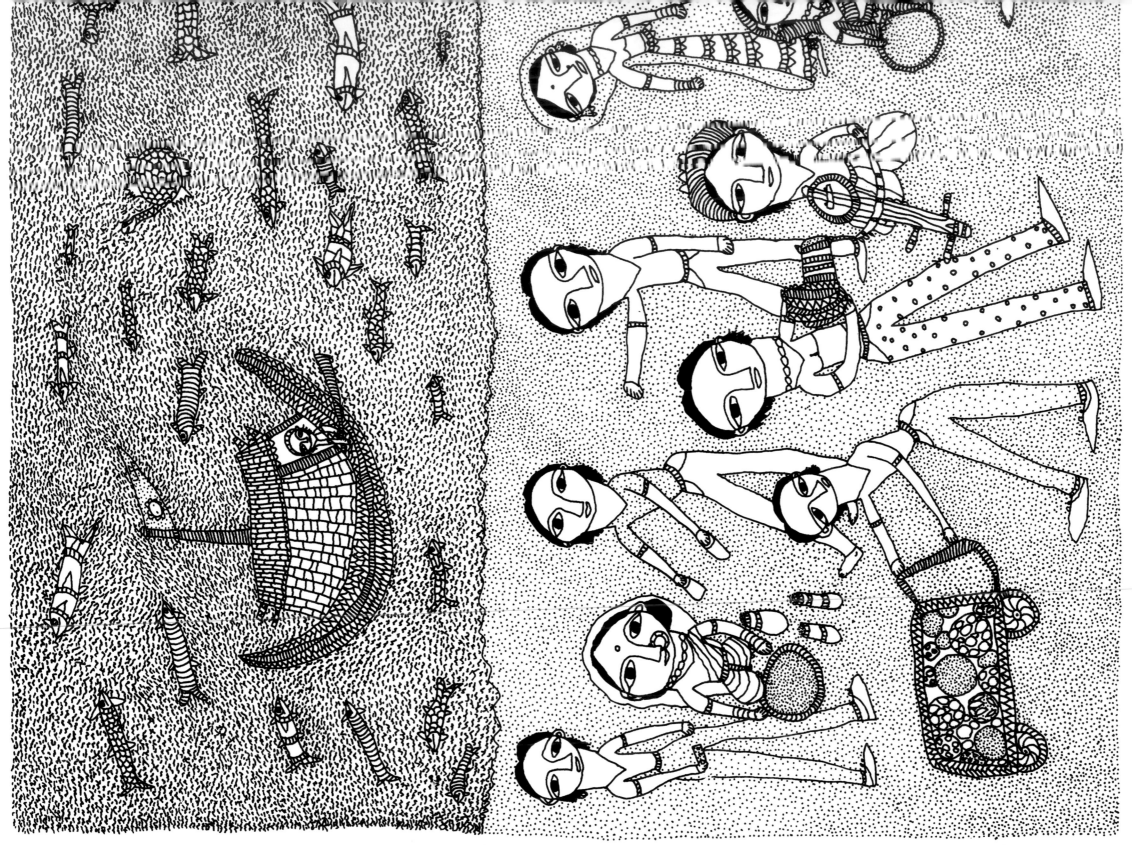

Ganeshbhai wants me to sing with him. I'm hesitant, woman in our community don't sing in public. But he coaxes me, and I remember Pa's music. Soon, between us, we have a range of songs — on hope and faith, the passing of seasons, and of love and surrender.

We become confident, decide to move on and sing for a living. All the way to Mumbai, says Ganeshbhai, who knows, we might sing in a film. I'm excited, but wary.

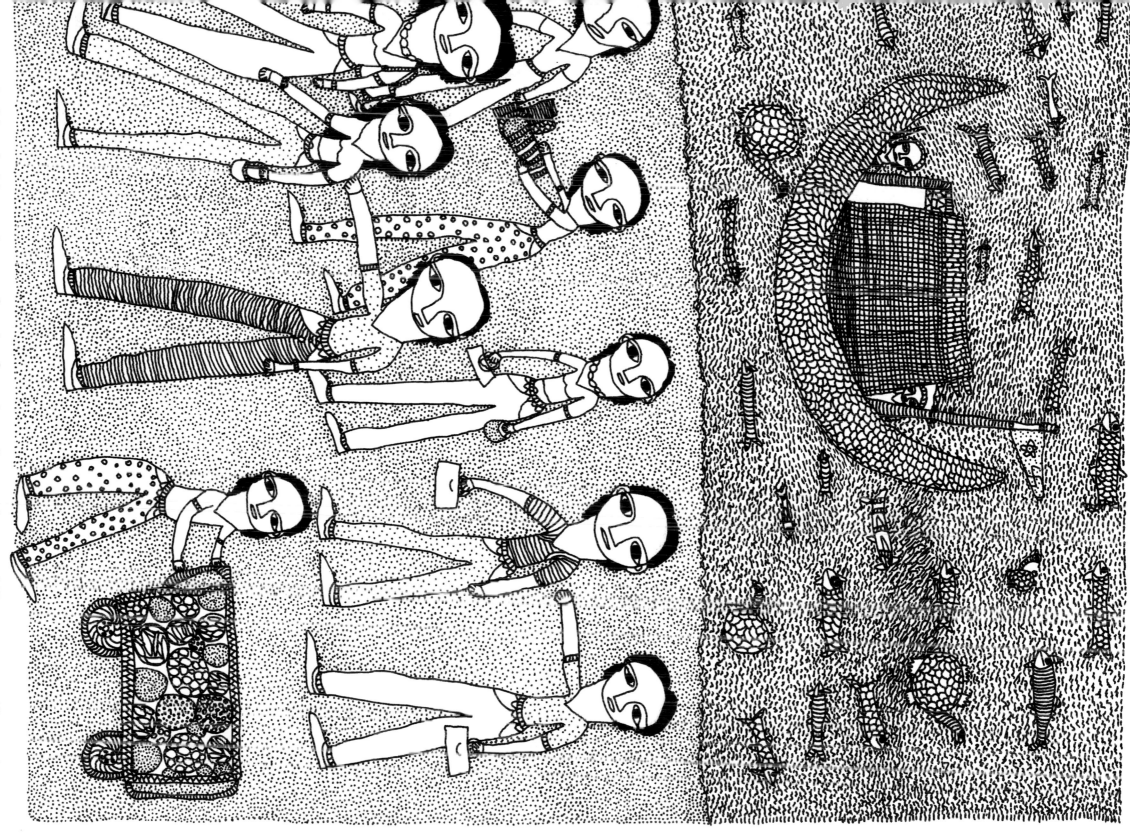

In Mumbai I see the sea for the first time. So much water! To stop myself watching the waves all the time, I turn my back to them as we sit on the sands singing and playing on instruments we have made.

Our hands are busy in other ways too — gathering coins that people throw to us. We need money to feed our growing family.

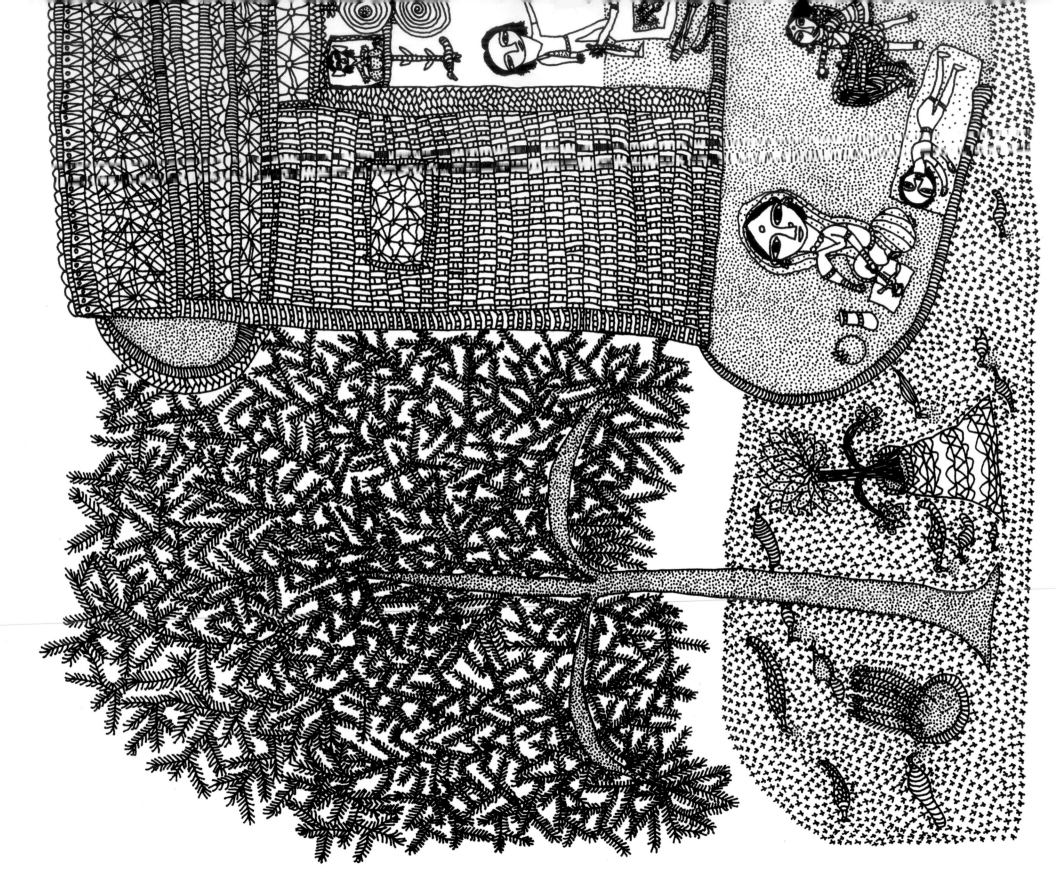

After a year, life becomes too hard, and we decide to return home. Just as we are beginning to wonder if things will ever improve, a piece of luck comes our way. Ganeshbhai meets an artist who finds him a job as a singer in a restaurant. I feel bold enough to join him.

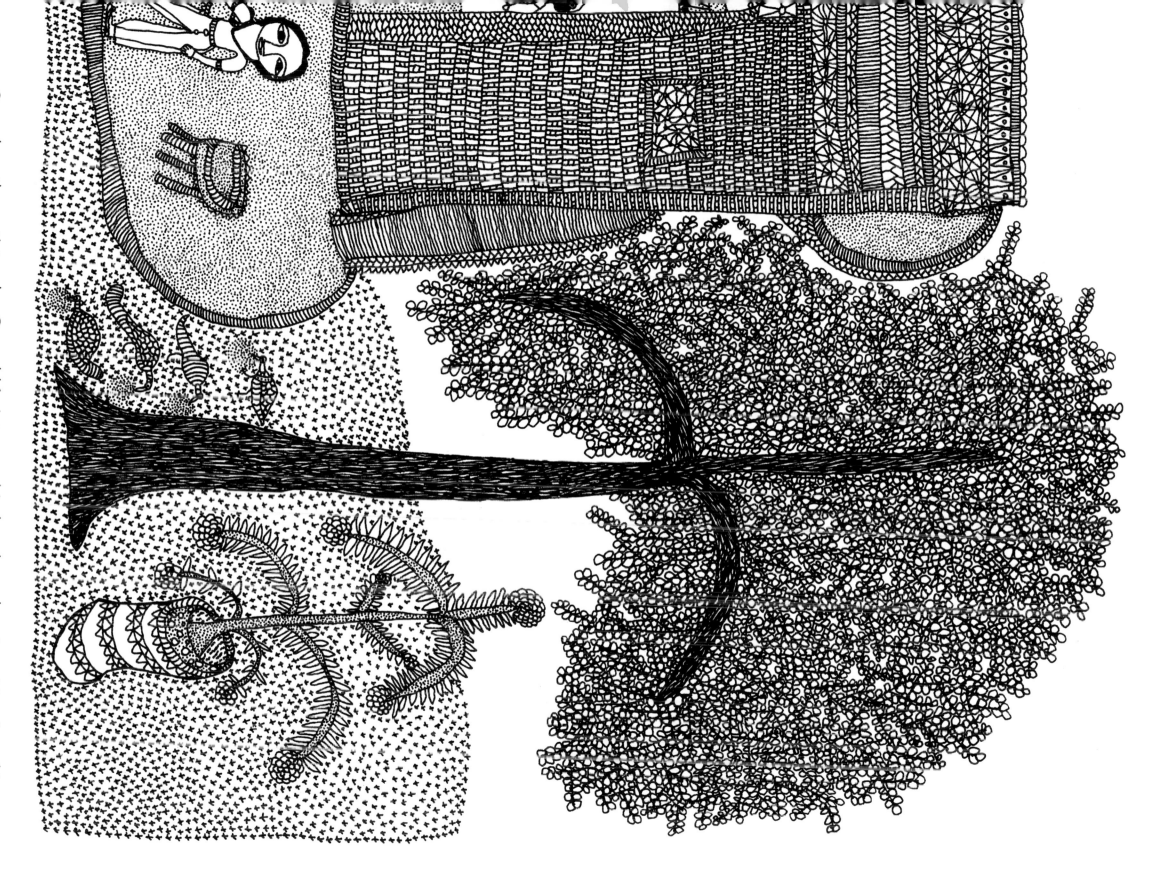

One day, the artist asks Ganeshbhai to try his hand at drawing. He gives him paper and pen, and before we know it, Ganeshbhai starts to enjoy himself. The drawings just come out of his hand. Will this drawing fetch us money, I wonder. Are we not better off singing?

And then Ganeshbhai says: why don't you try?

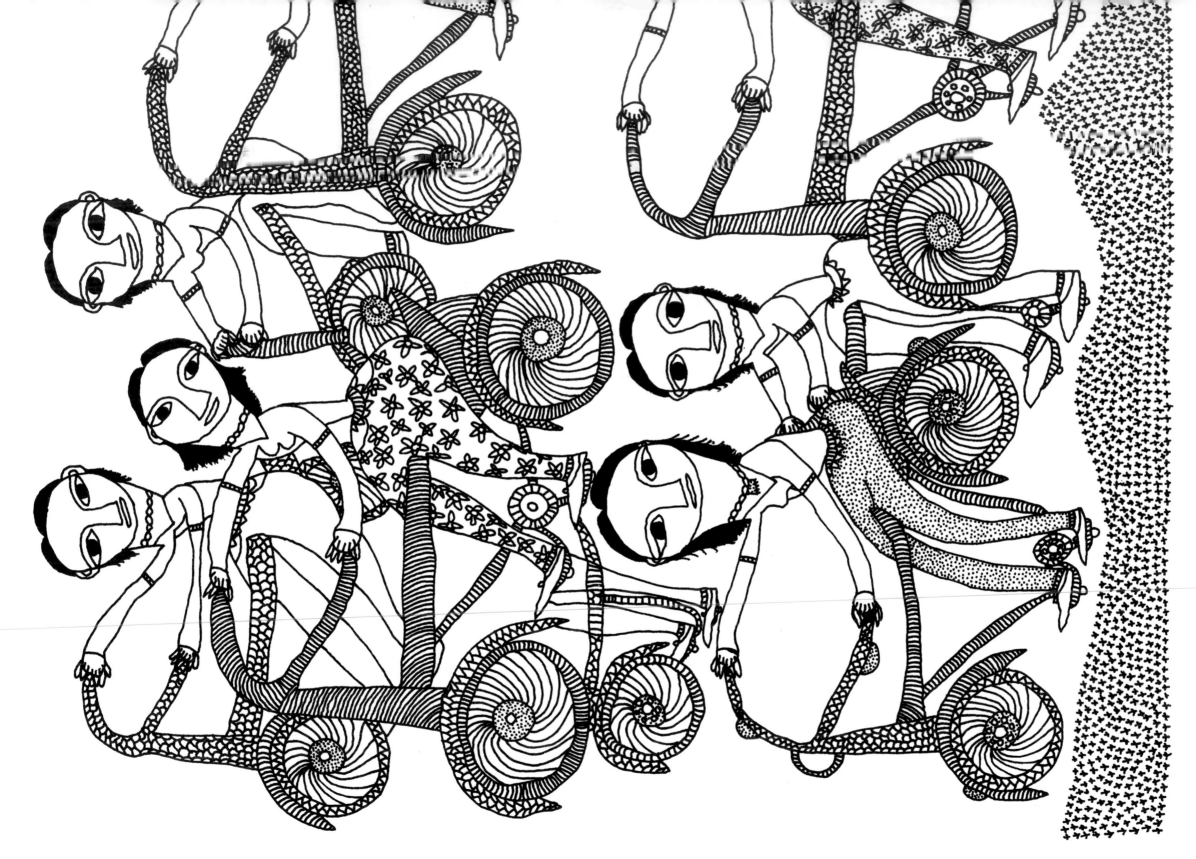

It is like magic. I sit in one place with paper and pen, and it is my hand that starts to move. Lines, dots, more lines, and more dots, and you have a picture. I can bring to life things that I have seen and known, but also things that I imagine. I can even bring the two together.

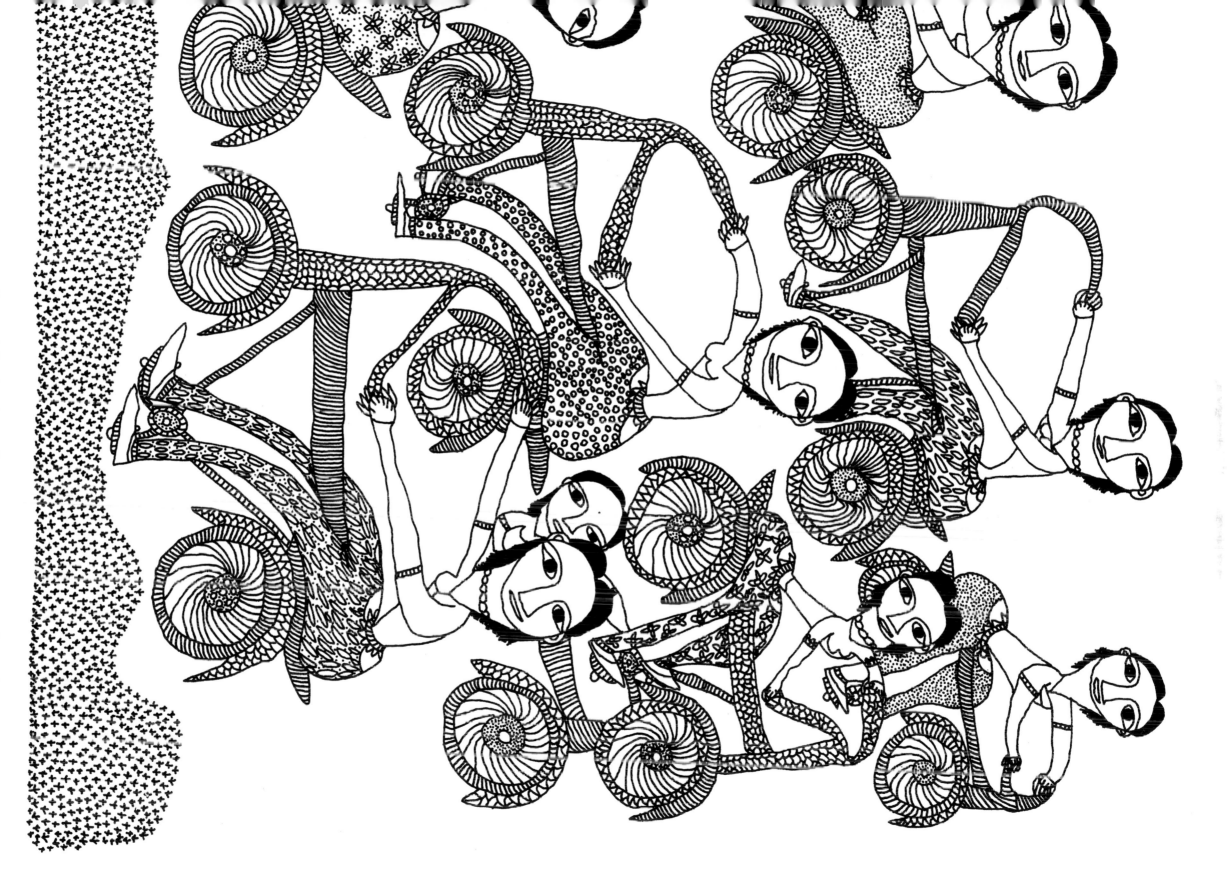

I have been moving all my life, looking for ways to survive, but this is a new direction. My heart is full.

I see a girl going somewhere on a bicycle, and I draw a whole group of girls, all of them on the way somewhere.

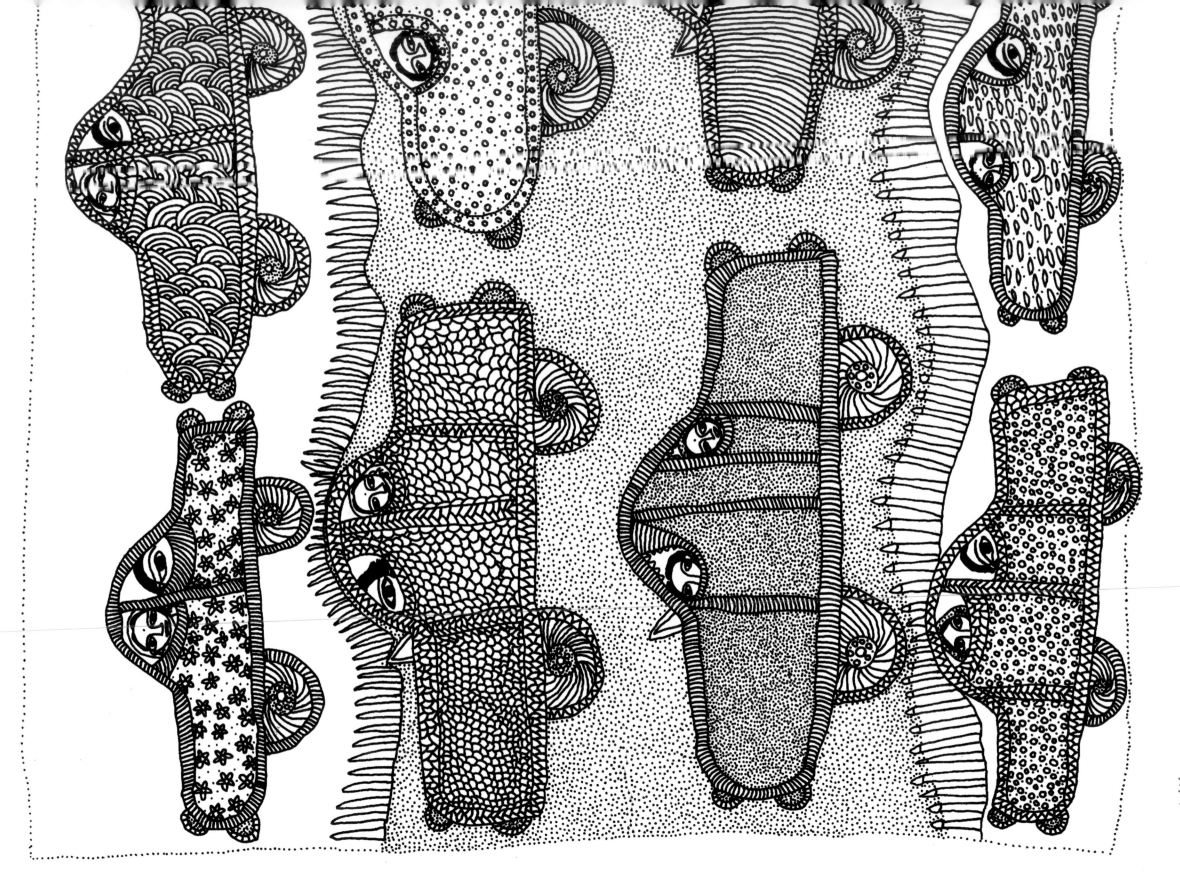

I like cars. I wonder what it is like to move at such high speed and to be in control of where you are going. There are always two women in my cars. One drives and the other looks out of the window.

I want to be both those women.

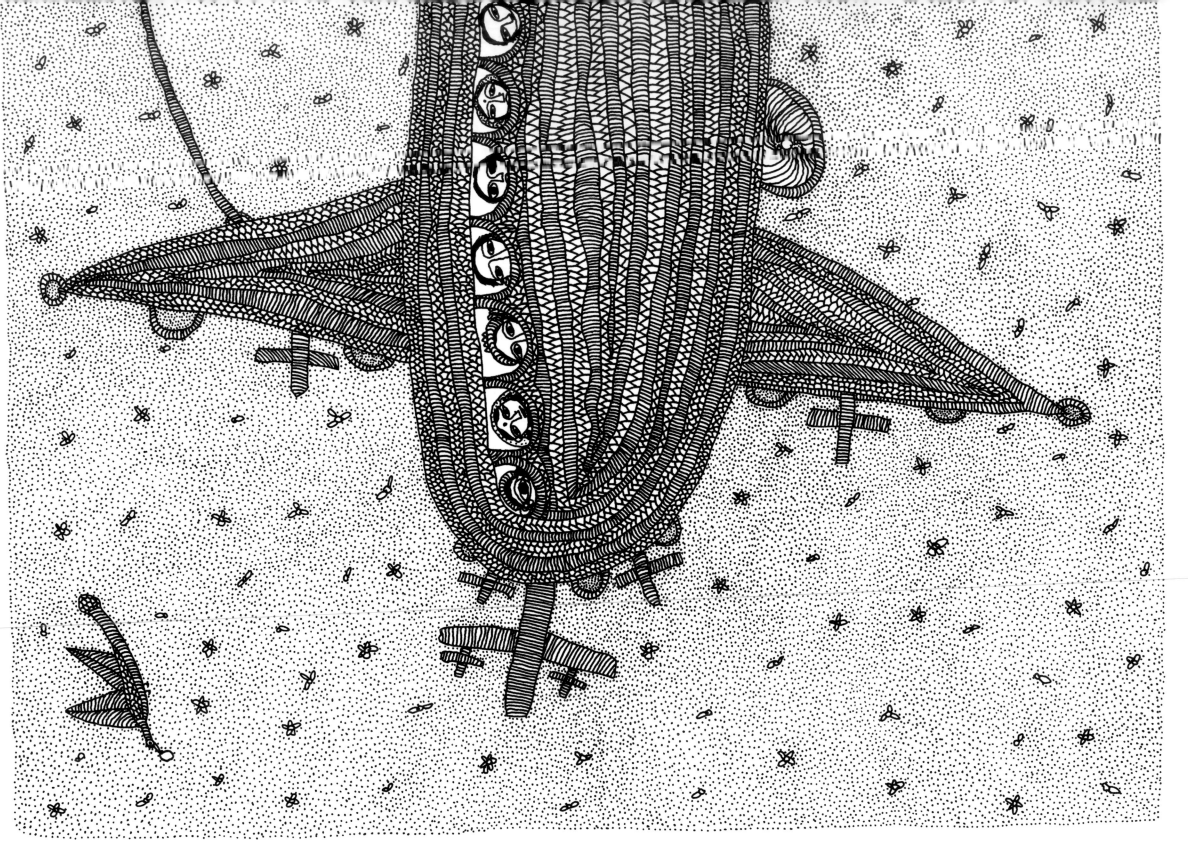

I watch big graceful birds that move silently through the sky.
When I was a child, great flocks of white birds would swoop quietly down onto the branches of our forest trees, and rest there for the winter.

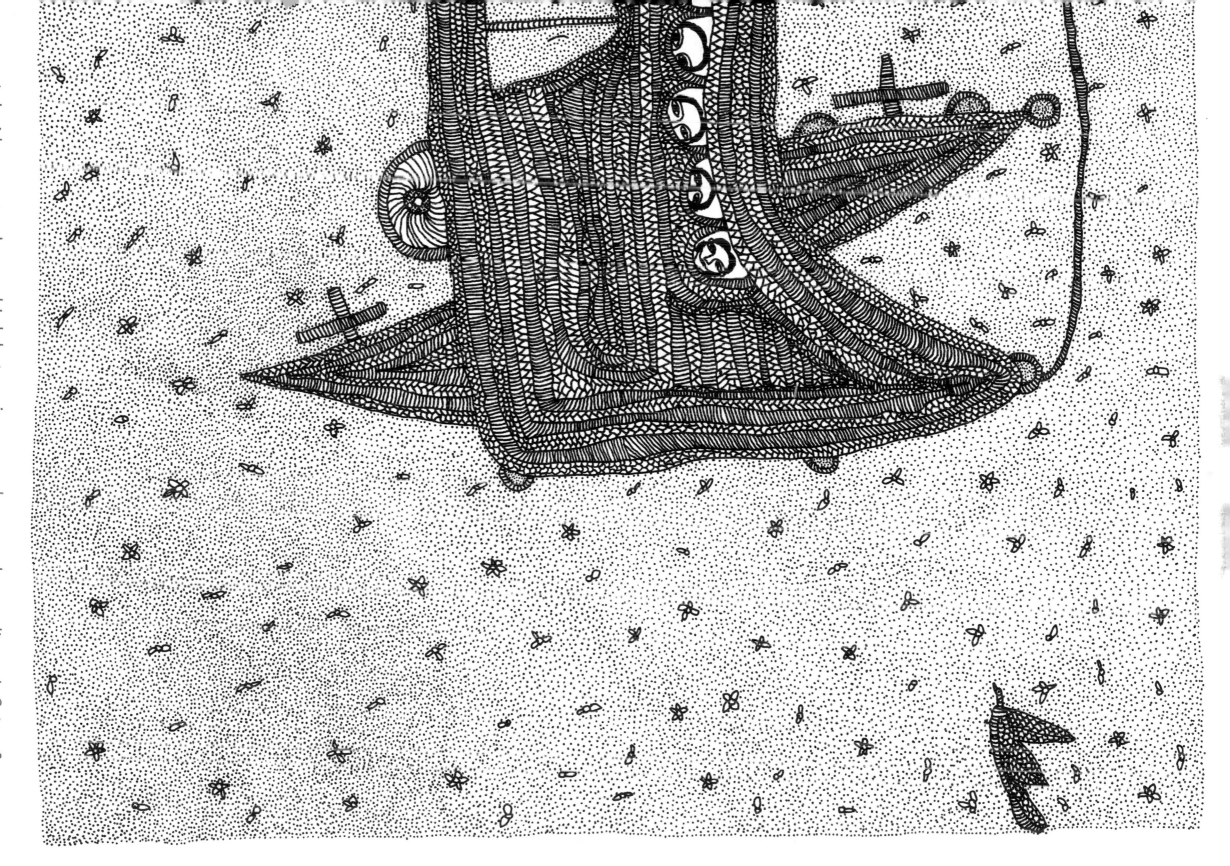

I decide now to draw a bird, but an iron one, large and complicated, flying from the city where I live. Or maybe it is flying to our city, carrying women on their way there.

I send some tiny birds along, just in case they need to know where to go.

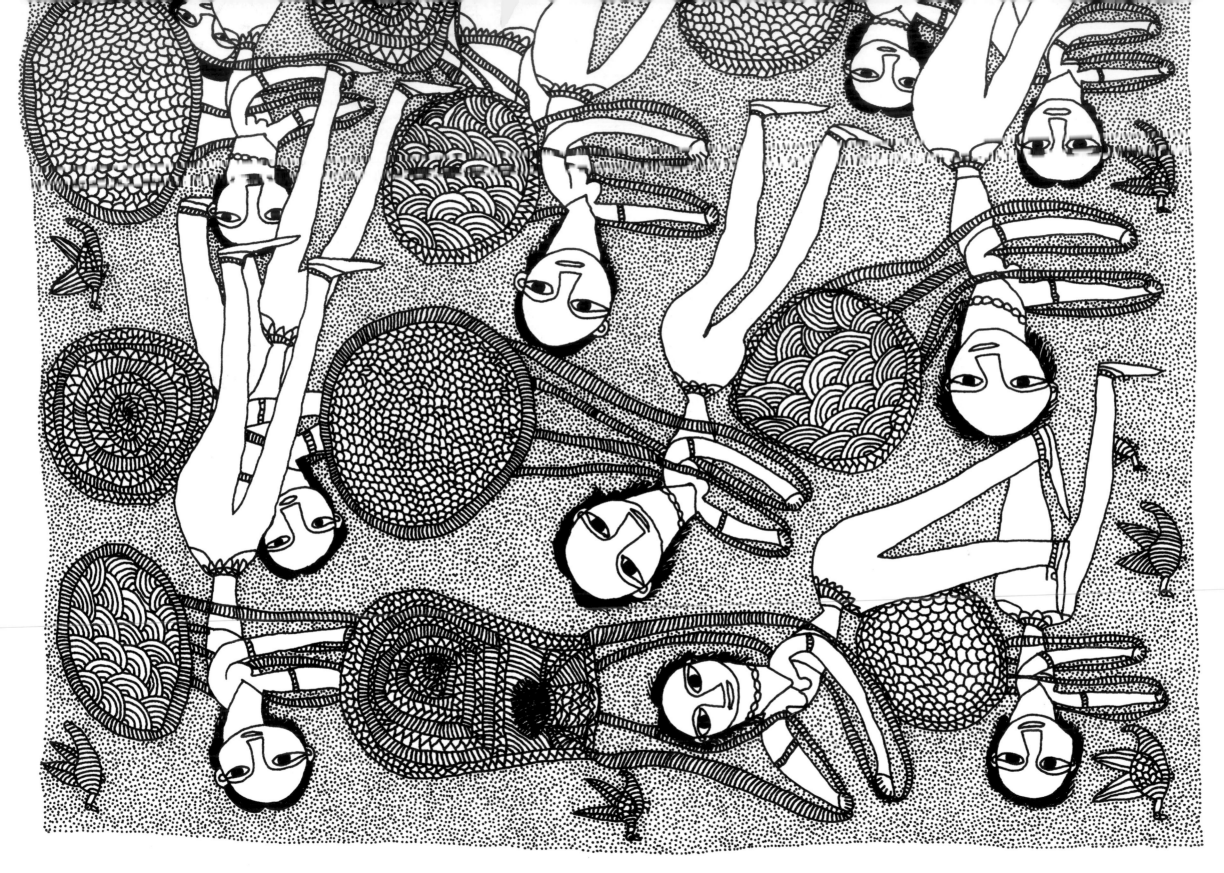

But even in the plane, my women are not content to sit still.
So I float them down, wondering where they should go next. Should they fly forever like birds? Or should I draw some lines taking them down to the sea?

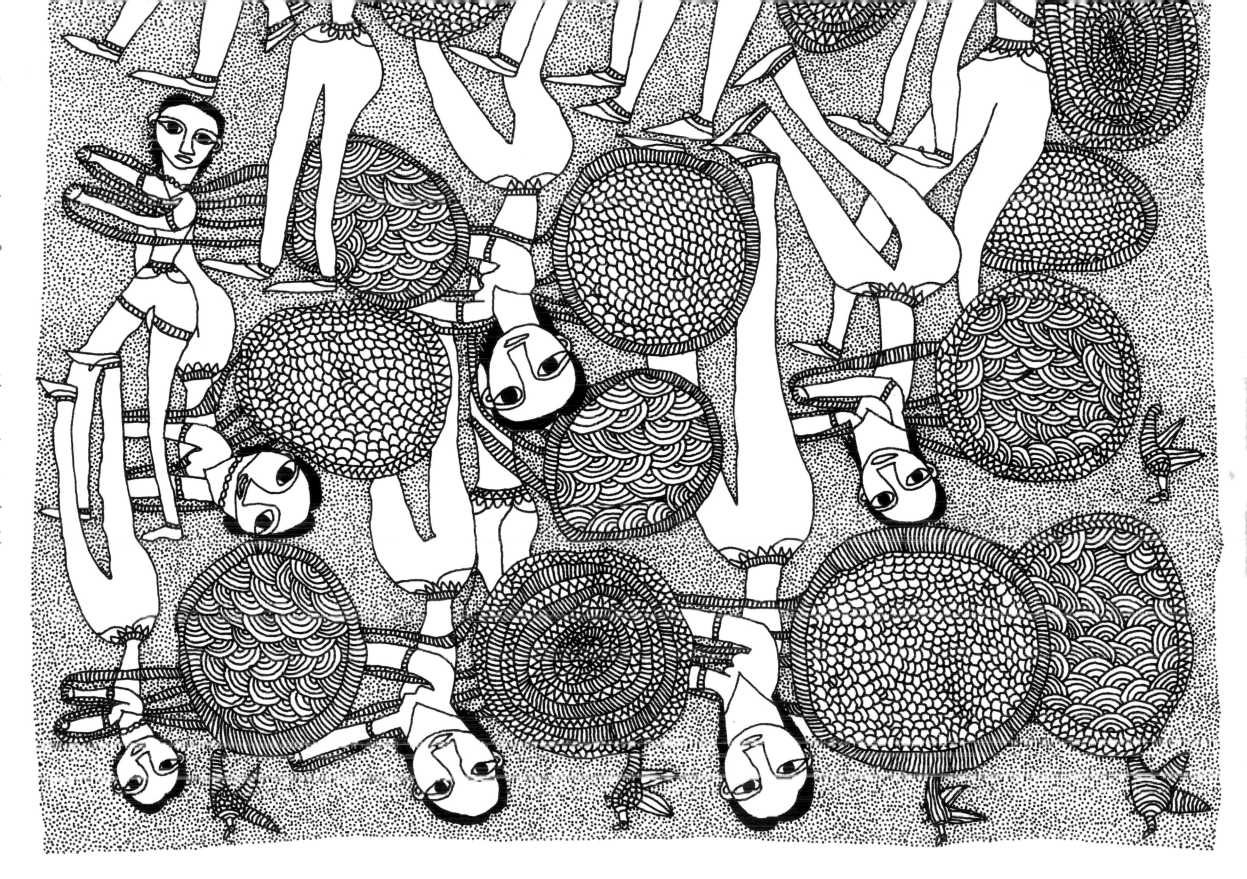

I rest my pen here, for a moment. I have time to decide.

We dedicate this book to the memory of Ganeshbhai Jogi, beloved husband of the artist Tejubehan. News of his passing came in just when this book was being completed.

Teju & Ganesh's Story

Born in Rajasthan and to music, Ganesh — and Teju — belonged to a community that wandered the streets, singing devotional songs. In return, the singers were given grain, clothes and some money. Like many old caste-based practices, this one has also lingered on in a fashion, but is no longer a viable occupation. Ganesh Jogi, like others in his community, had to make other livelihood choices. For a while, he did whatever work came his way, but some years proved harsher than others. His fortune charged when he met the remarkable artist Haku Shah in Ahmedabad, who encouraged him to draw. In his generous and unusual way, Ganesh then nurtured Teju's talent, disregarding what was considered appropriate for women in the community to do.

In *Drawing from the City*, Teju draws the story of her journey as an artist, which was so closely intertwined with that of Ganesh. It is at once a celebration and a tribute to his memory, to the art that this gentle and loving couple practised together. We hope that the book will stay with Teju, as a reminder of what she may yet do.

Drawing from the City
Copyright © Tara Books Pvt. Ltd. 2012
www.tarabooks.com

For the original Tamil text: Salai Selvam
For the English translation: V.Geetha
For the Art: Tejubehan

Design: Nia Murphy
Production: C. Arumugam
Printed and bound at AMM Screens, Chennai, India

ISBN: 978-93-80340-17-3